D0353720

GAINSBOROUGH

The life and work of the artist illustrated with 80 colour plates

GIUSEPPE GATT

NOTRE DAME HIGH SCHOOL

THAMES AND HUDSON

CLASS
Y59.2

Acc No
4423

Translated from the Italian by Pearl Sanders

This book is sold subject to the condition that it shall not, by way of trade or otherwise, be lent, re-sold, hired out, or otherwise circulated without the publisher's prior consent in any form of binding or cover other than that in which it is published and without a similar condition including this condition being imposed on the subsequent purchaser.

This edition © 1968 Thames and Hudson, 30–34 Bloomsbury Street, London WC1
Copyright © 1968 by Sadea Editore, Firenze
Reprinted 1979

All rights reserved. No part of this publication may be reproduced or transmitted, in any form or by any means, electronic or mechanical, including photocopying, recording or any information storage and retrieval system, without permission in writing from the publisher.

Printed in Italy

Life

Thomas Gainsborough was born in Sudbury, Suffolk, in 1727, the son of John Gainsborough, a cloth merchant. He soon evinced a marked inclination for drawing and in 1740 his father sent him to London to study art. He stayed in London for eight years, working under the rococo portrait-engraver Gravelot; he also had some contact with Francis Hayman and became familiar with the Flemish tradition of painting, which was highly prized by London art dealers at that time.

Gainsborough's first documented work, *The Charterhouse* (p. 15), was completed before he returned to Sudbury in 1748. In 1746 he had married Margaret Burr (believed to be the illegitimate daughter of the Duke of Bedford), and in 1750 he moved to Ipswich; two daughters were born of the marriage. In Ipswich Gainsborough's professional career began in earnest. He executed a great many small-sized portraits as well as landscapes of a decorative nature. To this period belong the two overmantel landscapes commissioned by the Duke of Bedford.

In October 1759 Gainsborough moved to Bath, the elegant and sophisticated spa where the height of English fashion congregated. He remained there until 1774 although frequent visits were made to London during those years. In Bath Gainsborough became a much sought-after and fashionable artist, portraying the aristocracy, wealthy merchants, artists and men of letters. He no longer produced small paintings but, in the manner of van Dyck, turned to full-length, life-size portraits.

He began to exhibit with the London Society of Artists in 1761 and in 1768 became a founder member of the Royal Academy. However, he broke off all relations with that august body in 1784 after a number of disagreements with the organizers (the first clashes had occurred in 1773); he removed his paintings to his house in Pall Mall and thenceforward exhibited there every year.

From 1774 to 1788 (the year of his death) Gainsborough lived in London where he divided his time between portraits and pictorial compositions, inspired by Giorgione, which Reynolds defined as 'fancy pictures'. Gainsborough began to work on these latter in 1780 and about twenty in all were produced. He also painted the royal family (George III, Queen Charlotte). His output includes about eight hundred portraits and more than two hundred landscapes besides the 'fancy pictures'. As a self-taught artist, he did not make the traditional grand tour or the ritual journey to Italy, but relied on his own remarkable instinct in painting. In contrast to his nephew, Gainsborough Dupont (1754-c. 1797), he neither had nor desired pupils, but his art – ideologically and technically entirely different from that of his rival Reynolds – had a considerable influence on the artists of the English school who followed him. The landscapes, especially those of his late manner, anticipate Constable; the marine paintings, Turner. Many of his landscape drawings form an authentic repertory of pictorial themes, which were widely drawn on and imitated, especially after the theory of the Picturesque became widely known through the efforts of Uvedale Price, whose father Gainsborough met in 1760.

Works

Although Gainsborough considered that his particular bent was for landscape, his official art is portraiture. Landscape art, by its very nature, implies a reliance on instinct and taste and a desire for an intimate communion with nature, however difficult this aim may be of realization. It implies also a wish to revive the tradition of the subject-matter of 'minor' art along the lines laid down by Dutch painters. Portraiture, on the other hand, is an art which must conform to the taste of the period (heir to the 'heroic' manner of seventeenth-century English portraiture, as derived from van Dyck). It is an art dedicated to flattering a particular social class and to meeting the requirements of a highly sophisticated and demanding clientele. One might say, in fact, that whereas landscape is a contemplative art, through which it is possible for the artist to find freedom, portraiture is restricted within the limits of a prescribed formula. Although in Gainsborough's case he was convinced that the necessity of following this formula did violence to his personal creative genius, it was nevertheless through its means that he was able to realize his finest archievements – unintentionally, as it were.

The particular discovery of Gainsborough, which required no revolution (for Gainsborough's revolution did not occur until almost a century later, with impressionism), was the creation of a form of art in which the sitters and the background merge into a single entitly. The landscape is not kept in the background, but in most cases man and nature are fused in a single whole through the atmospheric harmony of mood. This treatment does not signify a mystical return to nature (with the possible exception of certain of the 'fancy pictures') but is intended to make the landscape act as a framework for a civilized and highly cultured society, numbering among its members aristocrats, prosperous merchants and intellectuals, all leading a leisurely existence and taking the waters. It may be argued

that the drawing-room has been transferred to the countryside, but this is not the case: nature, in fact, has now come to the forefront of European culture and penetrated into the palaces of princes, as well as artists' studios.

It is no accident that the imaginary landscapes had their origins in the re-creation of natural objects in the studio: stones, leaves and tree branches. Nor is it an accident that in the works of Gainsborough's late maturity the figures blend with the background to such an extent that they become almost transparent. This effect was possible only by situating the figures in the background, not in order to add an element to the portrait, but with the sole purpose of achieving the greatest possible degree of naturalness. It was this same striving for naturalness which prevented Gainsborough from portraying his society people in historical costume or striking attitudes, in the manner of Reynolds, who was the rightful heir to the grand manner of heroic portraiture developed in the seventeenth century. Besides, in integrating man and nature in this way Gainsborough was merely following the artistic precepts of the eighteenth century. The question of the role of nature in art was predominant in all eighteenth-century discussion in Europe and it was at the root of the most significant movements of the time: Arcadia in Italy, Rococo in France, the romance of the seasons in England, and the theory of the Sublime, formulated most coherently in the philosophy of Kant. Gainsborough is a forerunner of the English illuminist school, and he may be described as an illuministic naturalist.

It is certainly true that Hogarth had already found a new approach to the subject-matter of painting and had treated it with a bold technique which anticipated the earliest examples of the Picturesque. In his case, however, nature occupied a secondary position and remained in the background as a means of situating the action. Ia was Gainsborough who initiated a new feeling for nature, and through his painting formulated an original conception of the relationship between figure and background; he emphasized that the natural background for his characters neither was, nor ought to be, the drawing-room or a recon-

struction of historical events, but the changeable and harmonious manifestations of nature, as revealed both in the fleeting moment and in the slowly evolving seasons.

This method of placing the sitter in direct contact with the landscape – a landscape, moreover, which was not a stereotype but highly individualized and unique in each of his portraits – was certainly a most effective answer to Reynolds' rhetorical portraiture, where the figure, in a historical attitude, was placed in relief against a background of minor importance, and the artist thus made a critical and comparative selection of the values he intended to emphasize. By giving equal prominence to all parts of the painting, Gainsborough – who from this point of view came close to Hogarth – was able to create a lively and natural work of art in which the *pathos* of man can be seen in the light of the background against which he is placed, so that he forms a single natural and psychological reality with nature. This was a distinct innovation at a time when the whole tradition was to extol an ideal and historical concept of beauty, to abandon nature and embrace artificiality. Each of Gainsborough's portraits is distinct and individual, even though, taken as a whole, they depict an entire society in its significant manifestations.

Although his art fitted the broad canons of eighteenth-century pictorial style, it is not possible to discover in Gainsborough any direct attempt to perfect nature or to transpose it onto an ideal plane. There is, if anything, a certain element of selection, motivated by the theory of the Picturesque, which leads him to orientate his choice to one or another type of landscape or, at the most, the likeness of the sitter is made to conform to the demands of a naturalistic typology.

In the portrait of *Robert Andrews and Mary, His Wife* (*pls 12-14*), for example, the beauty of the green English summer is communicated to the viewer through the sense of well-being and delight which the atmosphere visibly creates in the sitters. Gainsborough shows the pleasure of resting on a rustic bench in the cool shade of an oak tree, while all around the ripe harvest throbs in a hot atmosphere enveloped by a golden light. Since he was no theo-

retician, Gainsborough did not aim to formulate a new concept of nature, but contented himself with a sensuous response to her stimulus, without running the risk of spoiling the charm and spontaneity of nature by indulging in idealization or mannerism.

If, therefore, nature as portrayed by Gainsborough is neither idealized nor invented, it follows that the relationship between nature and art in his paintings is not one of imitation only, but that it participates fully in the process of growth and evolution through which nature manifests itself. There is, in fact, a spontaneous yielding (whose theoretical source lies not far away in the hedonism of Hume's 'rule of taste', defining beauty as a pleasure of the senses and taste) to the pleasure which this participation brings both to the artist and to the sitters, who are at last taken out of the artificial surroundings of the drawing-room and made aware of the simple and healthful joys of nature.

The readiness to yield to a sensuous delight in nature, which was characteristic of Gainsborough, made it impossible for him to accept the theory of the Sublime, and came closer to the concept of the Pleasing. For if a characteristic of the view of beauty as something pleasing is that it is to be found in natural surroundings and appreciated for what it is, it is typical of the concept of the Sublime to strive to transcend reality and become lost in a state of contemplation which may become the source of countless violent sensations. In this connection, we are reminded of Turner's alpine views, whose atmospheric strorms undoubtedly add to the sense of awe induced by the majestic landscape, which is made more powerful by the artist's choice of an exceptional aspect of nature; in contrast, Gainsborough's landscape pleases the eye because of its very simplicity and usualness. And since it pleases in this way, it differs also from the landscape of Constable, for whom 'nature' is synonymous with 'problem', as it was to be in the case of Cézanne as compared with the impressionists.

Gainsborough's painting is readily enjoyed and is not overburdened by too scrupulous an observance of rules and precepts. The immediateness and spontaneity which are

present in nature are present also in the work of art, to the extent of giving the impression that the artist's supreme ability consists in making even the most artificial and contrived elements appear entirely natural and spontaneous. It begins to seem a perfectly normal and everyday occurrence to come across such impeccably elegant men and women, strolling about in a homely wood or in the park belonging to their country seat.

We should therefore not be surprised that, as compared with French or Italian painting, the artificially produced English garden is represented as being far from artificial. Although it may be true to say that Gainsborough (and, for that matter, Hogarth and Reynolds also) could not avoid a certain affectation derived directly from the theatre, yet it is a fact that his gardens, his forests which resemble stage scenery, where elegant and carefree men and women, with refined, graceful gestures, idly stroll and converse, exemplify an ideal of life, nature and man ' *sub specie artis* '. From this point of view, the reality of nature and the ideal of art are made to coincide with what appears to be an almost miraculous degree of spontaneity, achieved by means of a process through which art becomes natural at the same time as nature becomes artistic. ' If Gainsborough did not look at nature with a poet's eye, it must be acknowledged that he saw her with the eye of a painter ', as Reynolds was to say on the death of his rival.

The recognition of a fundamental artistic treatment of nature is reflected also in English eighteenth-century poetry, especially in the verse of Thomson in 1726-7. Rosario Assunto wrote that in Thomson, ' the poetry-nature relationship is stated in terms which are not imitative but descriptive, in the same sense in which, thirty years later, Burke was to define poetry as a strictly imitative art. A descriptiveness, it must be added, based on a congeniality between poetry and nature, since the poet is the man who has restored himself to nature and, as it were, made himself one with her. '

Through the privileged genius of the artist, nature can be revealed in all his work, which is an expression of his sense

of unity with nature, pleasure in her silences and solitude, and the emotions he experiences before the varied manifestations of the seasons through which she lives. The most intimate and intrinsic aspects of nature thus become the principal element of the artist's aesthetic experience. Constable was aware of the imperceptible charm of Gainsborough's art when he said, 'The landscape of Gainsborough is soothing, tender, and affecting. The stillness of noon, the depths of twilight, and the dews and pearls of the morning, are all to be found on the canvases of this most benevolent and kind-hearted man.' But in addition to marking the changes which occur from hour to hour in the course of a day, Gainsborough dwelt also on the changes wrought by the progression of the seasons. I believe, in fact – though Waterhouse does not agree – that Gainsborough has made his own precise contribution to the art of the seasons.

Emphasis is nearly always placed on the season in both the landscapes and the portraits, from the time of Gainsborough's early works until the years of his late maturity: from the burning summer sun in *Robert Andrews and Mary, His Wife (pls 12-14)* to the early autumn scene in *Gainsborough's Forest*, also known as *Cornard Wood (pls 4-5)*; and to autumn again, in a work penetrated throughout by the richness and warmth of colour of this season, by its scents of drenched earth and marshy undergrowth – *The Market Cart (pls 74-6)*, painted in 1786-7, that is, shortly before Gainsborough's death.

In a series of paintings on glass *(pls 54-61)*, special prominence is given to the changing appearance of nature in the course of the seasonal cycles: winter in cold dawns at sea or in woods covered in hoar frost, autumn in the burned leaves and ochre colours of dry shingles, spring in limpid pools or on ranges of blue mountains in a crystal-clear atmosphere, summer in the still heat and the sails of motionless windmills.

The men and women portrayed in Gainsborough's paintings are themselves, of course, not immune from the cyclic rhythm of the seasons, and this factor of instability is mainly responsible for creating the 'natural portrait' which

contrasts with the historical fixity of Reynolds' 'idealized portraits': *John Joshua Kirby and His Wife (pl. 8)* are seated against a dry tree under a sky heavy with rain in an autumn atmosphere; the season is autumn again in the portrait of *Edward, 2nd Viscount Ligonier (pl. 33)*; while there is a feeling of spring in the cool garden where polite conversation is exchanged against a background of a small classical temple *(pl. 1)*. The dazzling light which penetrates the shady recesses where Elizabeth and Mary Linley have found refuge for their spiritual meditations trembles in a wintry cold (p. 29).

This painting of the Linley sisters – as well as certain others, such as the portrait of Viscountess Ligonier *(pl. 34)*, *The Blue Boy (pl. 35), Mrs Hamilton Nisbet (pl. 70), Georgiana, Duchess of Devonshire (pl. 48)* – contains a new element in Gainsborough's emotional response to nature: an overpowering melancholy, inherent in the landscapes as much as in the figures, which pervades with its own indefinable pathos the scenes of both rural life and elegant society. There can be no doubt that an original and precocious contribution was being made by Gainsborough to the category of the Sublime, although, as has been pointed out, this does not mean that he formulated a cogent system of his own. It is perhaps just because his art does not easily fall within a well-defined theoretical system (as indicated by the expressive freedom of his backgrounds) that it became a forerunner of the romantic movement, with its feeling for nature and the uncertainty and anxiety experienced by sensitive men when confronted with nature. In the portrait of Elizabeth and Mary Linley (p. 29), Gainsborough went so far as to make an Ossianic type of psychological exploration (Macpherson was born in 1736 and died in 1796); he also came close to the pre-Raphaelites, whose art found its most typical expression about eighty years later in the 'sublime' atmosphere surrounding the creations of Dante Gabriel Rossetti.

Gainsborough's incursions into this incipient – but, so far, inconsistent – climate were of a sporadic character and were always followed by a speedy return to the reassuring atmosphere of unruffled calm in which nature brought

happiness to the protagonists of the scenes of rural life: the peasants whose lives were spent in constant communion with nature, and the refined, elegant society of holiday-makers to whom the beauty of nature brought serenity and the opportunity of losing themselves in unaffected contemplation, as the busy life of the city made it impossible for them to do. The same may be said also with regard to the behaviour of his characters both in the country and in town, which displayed a *noblesse* similar to that which was common in the fashionable drawing-rooms. At the same time, this view of society conformed to the new ideal of education for the upper classes, which held that 'the aim of real education ... is to free the individual from the weight of a load of conventions, to make him natural, to permit him to live and move about in society with the same spontaneity and the same unaffected responsiveness as one who lives and moves in his own natural surroundings' (Argan).

Gainsborough constantly analyzed character, and this preoccupation derived from his view of painting as an explorative art, the effort of the 'active mind', able through 'wit' and insight to represent even that which is unseen, and make it visible. These qualities enabled Gainsborough to embark on authentic psychological adventures. For example, he was able to amalgamate in one and the same spiritual dimension totally dissimilar elements, such as figures and landscapes, high society and rural life. And he could achieve this without descending to generalizations but, on the contrary, making a profound analysis of objects and portraits and causing the surrounding nature to appear at times as a reflection of the particular view of it held by the character portrayed.

The form taken by the Sublime in certain of Gainsborough's works is affected to a certain extent (though perhaps only indirectly and at the level of a common cultural language) by the definition of this category made by Burke in 1756. This was shortly before Gainsborough began work on the paintings of his Bath period (1759-74) which, together with those of the London period (1774-88), stand at the summit of his artistic achievement.

The element in Burke's aesthetics which we can see reflected in the painting of Gainsborough is certainly not the concept which considers the ' sublime ' to be a violent emotion of grief, terror or danger – a meaning substantially close to that of Kant in his *Critique of Pure Reason* and quite foreign to Gainsborough's point of view, although it may at times coincide with Turner's, and came fully into its own with Fuseli and Blake. It is to be sought rather in the ' anti-classical ' factors inherent in this concept – a determination especially to transcend the rationalistic theories formulated by Pope in his famous *Essay on Criticism* (1711) in favour of the indeterminate nature of artistic creation which, from the very beginning of the century, was at the root of the whole aesthetic concept of the Picturesque. (This concept was to find its theoreticians in Cozens, 1759, and Price, 1794.) The Picturesque was opposed to the aesthetic theory of classical art, an art founded on intellectual clarity, order and a transference of the artist's serenity onto the subject of his art.

It is possible, therefore, to trace the influence of the idea of the Sublime in two salient features of Gainsborough's art. First, from the aspect of the artist's vision, it implies a particular view of the world, contemplative, enthralled, fully immersed in the natural scene and – as has been said – involved in the progression of the seasons. Second, from the point of view of execution, although it appears partly in the form of a virtuoso display of amazing technical skill and craftsmanship, it is fundamentally a reflection of the taste for that which is vaguely defined, unfinished and only indicated, and a representation of indefinite and unstable states of mind. This second aspect soon overflowed into the category of the Picturesque, where by dazzling the eye and subtly disturbing the spirit, the artist fused together sensitivity and imagination.

In the work of Gainsborough, therefore, we see an anticipation of the two concepts – the Sublime and the Picturesque – which, towards the end of the eighteenth century, were to divide art into two distinct and complementary camps, essentially with Blake, Constable and Turner.

If, in fact, in many of the paintings, both landscapes and portraits, Gainsborough uses atmosphere in order to cast a clear light on his subject and sharpen outlines, in many others (*The Hon. Mrs Thomas Graham* (*pls 40-1*), *Mrs Sarah Siddons* (*pls 65-6*), *Walk in St James's Park* (*pls 51-3*), the portrait of Elizabeth and Mary Linley (p. 29) and many of the 'fancy pictures') he prefers chiaroscuro, indefinite tones, contrasts of light and shade – that is to say, all those effects which do not serve as a basis for a study of light but rather stimulate the sensibility, emphasizing the pleasing and somewhat disturbing attributes of the object to be contemplated, the typical attributes, in fact, of the Picturesque.

Contrasts of light and shade in a context of flowing, curved and broken lines, produce an impression of animation and mobility which is the characteristic of Gainsborough's art. This mobility is directly connected with his technique of seizing an effect in a rapid stroke, so that a beauty of form emerges from his bold execution, masterly technique and the exactness of his improvisation through which the scene appears to have been blocked in as under a flash-bulb. These qualities, of course, are what constitute the technical perfection of the painting and make it a source of sensuous and therefore aesthetic pleasure. This mobility in his works is not, however, confined to a sense of restless physical instability in the figures or landscapes as a direct consequence of the artist's particular formal technique, but passes beyond into the *pathos* of the characters whose feelings seem to be uncertain, unstable and fluctuating. A mobile and weightless quality is found also in the background details and the draperies, where vibrant patches of light have a fluid, translucent consistency which recalls the manner of Rubens and anticipates Goya. The formal elements of the painting – colours and lines – thus become expressive in their own right; this expressiveness transcends the actual themes the painter is depicting and brings to the fore the question of perception, a perception of detail in every brush-stroke, and the consequent non-representational quality in Gainsborough's work for which Reynolds was to reproach him.

On the other hand, Gainsborough's conception of man as changing according to the emotions to which he is subject is connected with his view of nature as something which is not static but follows a free and variable rhythm imposed by the seasons and by time. This attitude represents a contribution to the 'naturalistic-emotional idea which became one of the marks of English taste between the last years

The Charterhouse (see pp. 18-20)

of the eighteenth century and the beginning of the nine-teenth' (Assunto). This view, together with the empirical philosophy which identified the beautiful with the pleasing, had its counterpart in the classical ideal of an art of reason and intellect, where the representation of nature followed rational principles, without any disturbing flights of fancy or emotional overtones.

Then, also, there is the principle of variety which has been referred to previously, which besides uniting landscape and figure, society and nature, acquires further meaning in the mobile psychological and sensuous effects connected with the broken line of the picture (which is a coloured drawing), animated by an inner fire: that is, a mystical whole made up of technique, excitement and enthusiasm. Shaftesbury said that the artist does not copy something external, but gives form to its impetus, actuates its spirit and produces a new being.

Taking into account the sensuous use of colour which has an ever-growing tendency to free itself from the intellectual rigour of the outline, these are the fundamental grounds for the opposition between 'naturalistic' Gainsborough and 'classical' Reynolds. It is the same contrast that, in poetry, divides Pope from Milton and Ossian: an ideal of the beautiful as 'pleasing' and 'gracious', changeable and indefinable (just as in so many of its aspects reality too is indefinable), which is opposed to an incorruptible 'ideal' beauty, uplifting and sublimating. There was also, of course, a fundamental difference in their respective views of nature. Reynolds spoke of 'the general idea of Nature' and explained, 'whatever notions are not conformable to those of nature, or universal opinion, must be considered as more or less capricious' (*Seventh Discourse*); while Gainsborough was faced with the inescapable search for an answer to the problem of expressing a particular vision of nature, whose general norm came close to the definition of the Picturesque.

Gainsborough and the Critics

While he was alive Gainsborough gained considerable success and prestige with the public as well as the flattering rewards of academic recognition. Immediately after his death the importance of his work was acknowledged when his great rival, Sir Joshua Reynolds, pronounced his official obituary discourse at the Royal Academy.

Gainsborough's influence on the development of European painting, through Turner and Constable to the impressionists, has been revealed in the copious bibliography which has accumulated in the course of nearly two hundred years. For a comparative bibliography the reader should consult Ellis K. Waterhouse, *Gainsborough* (London 1958); this is a basic study of the artist, especially in tracing and dating his enormous production. W. T. Whitley's *Thomas Gainsborough* (London 1915) is an extremely useful biography, and P. Thicknesse, *A Sketch of the Life and Paintings of Thomas Gainsborough, Esq.* (London 1788), is of interest because the author was a friend of the artist.

Important recent criticism is contained in the writings of G. C. Argan (see his essay in *Scritti in onore di Mario Salmi*, Rome 1963, and *La pittura dell'Illuminismo in Inghilterra*, Rome 1965). Other works which may be consulted with advantage are: E. K. Waterhouse, the article ' Gainsborough ' in *Encyclopedia of World Art*, v. V (London and New York 1961); Keith Roberts, ' Gainsborough ', *The Masters*, No. 32; V. Photiades, *La pittura del XVIII secolo* (Milan 1963) – though superficial and hasty in its judgments on Gainsborough; G. Carandente, Catalogue to the exhibition ' English Painting from Hogarth to Turner ', Rome 1966.

For an overall picture of the general problems concerning English eighteenth-century artistic theories, the following works are useful: D. Hume, *The Rule of Taste*; W. Hogarth, *The Analysis of Beauty*; L. Venturi, *Storia della critica d'arte* (Turin 1964), pp. 147 *et seq.*; and R. Assunto, *Stagioni e ragioni dell'estetica dell'Illuminismo* (1967).

Notes on the plates

1 Lady and Gentleman in Landscape, c. 1746. Oil on canvas, 76×67 cm. Paris, Louvre. This painting, known also as *Thomas Sandby and Wife*, was sold in 1832 at Erlestoke Park as *Gainsborough and his wife*. Waterhouse believes that this latter identification is the more likely, and most art historians agree with him.

2-3 Road through Wood, with Boy Resting and Dog, 1747. Oil on canvas, 100×14 cm. Philadelphia, Pennsylvania Academy. This is a typical ' genre painting', obviously influenced by Ruisdael, but also by Claude Lorraine. In many aspects this work recalls Constable's *Cornfield*.

4-5 Gainsborough's Forest (Cornard Wood), 1748. Oil on canvas, 120×150 cm. London, National Gallery. According to a letter written by the artist in 1788, this painting was completed in 1748 and – as in the case of the slightly earlier, but less developed, *Road through Wood, with Boy Resting and Dog* – has a minute attention to detail and a somewhat theatrical manner of treating the sky and trees, which clearly reveal the influence of German and Dutch landscape artists, especially Ruisdael. On the other hand, the treatment of the rustic figures bears the tangible mark of the French rococo artists, Boucher and Fragonard. Speaking of this painting, in the letter of 1788 referred to previously, Gainsborough wrote, ' It is in some respects a little in the *schoolboy stile* – but I do not reflect on this without a secret gratification; for as an early instance how strong my inclination stood for Landskip, this picture was actually painted at Sudbury in the year 1748; it was begun *before I left school* – and was the means of my Father's sending me to London.'

The Charterhouse, 1748 (black and white illustration on p. 15). Tondo, diameter 56 cm. London, Foundling Hospital. This work and those described above (*pls 1-4*) mark the salient points in the period of Gainsborough's apprenticeship, a period which may be considered to have come to an end in 1748. In this early period Gainsborough was subjected to the two opposing influences of the French and Dutch schools. It is probable that the manneristic style of the French school caused a reaction which impelled him towards the realistic study of nature developed by the Dutch. He adopted certain elements of French art after coming into contact with the engraver Hubert Gravelot, a pupil of Boucher. This was in 1740-8, when the engraver was working on some commissions for book illustrations and on the decoration of the pavilions of the Vauxhall Gardens. It is believed, according to Lawrence Gowing, that Gainsborough may have taken an active part in the decoration of some of the pavilions, with pastoral and rustic scenes painted in the rococo manner. He came to know Dutch painting through his work as a restorer, and made

a careful study of the landscapes of Jacob van Ruisdael, Wynants, Van der Heyden and others which he came to know in this way, as well as through local exhibitions.

It can be said that the realistic attention to detail found in Dutch and German painting (it appears that Gainsborough may have copied Dutch landscapes, from a letter he wrote to Thomas Harvey of Catton on 22 May 1788 in which he speaks of his 'fondness for my first imitating of little Dutch Landskips'), as well as the solid foundation of concept and theory which formed the basis for this

Self-portrait (see p. 26)

research into naturalism, formed the most effective antidote to the artificiality of the French school of art, as hedonistic and over-refined as it was lacking in fundamental concepts. Both these influences, though contrasting, are found together in Gainsborough, who saw in the minutiae of Dutch art a reflection of his own interest in the world of direct sensation and in everything which may become a source of agreeable experience, while admiring the rococo for its prodigious technical skill, its taste for free improvisation as a source of delight and pleasure – gifts with which Gainsborough's own talent was similarly endowed. It should also be noted that the synthesis or blending of the two styles, ' with more or less Dutch tree forms but put together with a rococo art, was not original to Gainsborough but was common form in the artistic *milieu* in which the young Gainsborough was brought up ' (Waterhouse).

On the other hand, we do not find in Gainsborough any traces of the classical culture of Italy (apart from an indirect influence which may have come through Salvator Rosa), either in the form of the Renaissance or the Baroque. The fact that he did not take the usual journey of study to Italy is another proof of his instinctive lack of interest in Italy, which was rather exceptional when we consider that it was through a dialectical confrontation with the Italian Renaissance and classical art in general that the English school, from Hogarth onwards, learned to recognize itself as such. Gainsborough's interest in the ancients was limited to what he knew about them and never extended to an awareness of the important part they occupied in the history of art or, as in the case of Reynolds, to a belief in the superiority of classical art over the art of modern times. This was true in spite of the illustrations which he made as a young man for Birch's *Lives of Illustrious Persons in Great Britain* (1743), in which he was able to show the skill he had acquired in this field when working with Gravelot. Besides, Gainsborough's lack of a sense of history was not limited to the past but extended also into the future, and confirmed his own conviction, as solid as it was instinctive, that he was not called upon to paint for posterity, but only for his demanding clientele or his own pleasure. It is in this context that we must understand his aversion for study and for literature in general, as well as his constant concern to shun the company of men of letters. It was on this basis that Gainsborough created his early works, striving to develop his style in as personal and original a way as possible. But he was later forced to adapt his art to the current taste of the worldly society which employed him. This society imposed its own standards and choice of subject matter on the artist, and it is strange that this should have been the case with someone like Gainsborough, of whom his friend Thicknesse was to write: ' of all the men I ever knew, he possessed least of that worldly knowledge, to enable him to make his own way into the notice of the Great World. '

6-7 Heneage Lloyd and His Sister, c. 1750. Oil on canvas, 63.5×80 cm. Cambridge, Fitzwilliam Museum. In the portraits

Mary, Countess Howe (see p. 28)

produced during Gainsborough's Ipswich period (1750-9) – of which one of the most representative is the portrait of *Robert Andrews and Mary, His Wife* (*pl. 12*) – we already find the central theme of Gainsborough's art: that is, the relationship between the sitter and nature. But we must not overlook the very important series of small portraits which he executed especially for his friends and relatives, in which he showed great originality in attitude and treatment: *John Joshua Kirby and His Wife* (*pl. 8*), *John Gainsborough* and certain self-portraits, all based on a close adherence to reality, without flights of imagination or ornamentation. When Thicknesse visited Gainsborough's studio for the first time in 1753, he observed that these portraits were 'truly drawn, perfectly like, but stiffly painted'. It was from the rococo, whose elegance and refined lyricism were absorbed by Gainsborough through his contact with Gravelot (who portrayed his sitters in graceful attitudes and rather exaggerated poses, with the aid of studio lay figures) that Gainsborough came to adopt artificial aids: he reconstructed fictitious landscapes in his studio, with the aid of branches, leaves, stones and mirrors. Sir Joshua Reynolds in his *Fourteenth Discourse* (1788) says that 'from the fields he brought into his painting-room stumps of trees, weeds, and animals of various kinds; and designed them, not from memory, but immediately from the objects. He even framed a kind of model from landscapes on his table; composed of broken stones, dried herbs, and pieces of looking-glass, which he magnified and improved into rocks, trees, and water.'

It was from Gravelot also that Gainsborough learned to confer on his portraits that typical expression of ingenuous and vague stupor that we see in the portrait of *John Joshua Kirby and His Wife* (*pl. 8*), *John Browne, with Wife and Child, Heneage Lloyd and His Sister, Philip Thicknesse, John Plampin of Chadacre*, and many others. In this connection, William Jackson's testimony is of great interest: 'He made little laymen for human figures. All the female figures in his Park scene he drew from a doll of his own creation. He modelled his horses and cows, and knobs of coal sat for rocks – nay, he carried this so far, that he never chose to paint anything from invention, when he could have the objects themselves. The limbs of trees, which he collected, would have made no inconsiderable woodrick, and many an ass has been led into his painting room.'

Unfortunately, certain art historians have taken this testimony as a reason for condemning the whole art of the English eighteenth-century school. Vassily Photiades, for example, evidently failing to grasp the importance of this new type of genre painting called by the English a 'conversation piece', wrote in reference to English painters. 'the insipidity, the affectation, the almost uniformly conventional style, the thousand artifices used by those whom we might call "court painters" find in this land, where the sweetest sentimentality reigns, a disastrously fertile terrain.'

The pre-eminence of colour at the expense of form led to the creation of works, according to the same author, 'which lack, first and foremost ... any structure', so that 'the characters portrayed, their

Margaret Gainsborough (see p. 30)

clothes, arms, materials, sometimes appear as stiff as cardboard, and are sometimes of an alarming inconsistency. A sleeve, for example, may seem to be empty of the arm it covers, a leg may look like a piece of heavy armour.'

These extracts have been quoted fully here, not because they can be said to have any kind of importance as criticism, other than a negative value, but in order to show the serious insufficiencies which arise in the type of criticism where value judgments are based exclusively on the painting's close resemblance to the model; and also to refute the argument of those critics who have used these same artifices as the grounds for upholding the view that there exists an area of artificiality between nature itself and Gainsborough's view of it – for although this view did not encompass the enraptured and direct vision of a Turner or a Constable, yet it nevertheless introduced a completely new element when seen against the preceding topographical tradition and, in the fictitious landscapes, gave rise to an art of the seasons and atmosphere. To this period also belong the early landscapes with rustic scenes of a decorative nature, in which Gainsborough used the subject-matter of the French *pastorales* of Boucher and treated it in the manner of Dutch and Flemish artists, with noteworthy success and originality of expression. See, for example, *Woody Slope with Cattle and Felled Timber (pl. 9)*, *View of Cornard Village (pls 15-17)*, *Woodcutter Courting a Milk-maid (pl. 22)*.

8　John Joshua Kirby and His Wife, c. 1750. Oil on canvas, 76×63.5 cm. London, National Portrait Gallery. Exhibited in Rome in 1966. Although in his lifetime John Joshua Kirby obtained academic honours and court commissions, he was a modest artist. However, Gainsborough, who had become a close friend of his when they met in Ipswich, painted this portrait of him with his wife. It is not one of Gainsborough's best works, but the judgment of De Martino given in his review of the Rome exhibition of 1966 (*Estro* 1-2, Jan./Feb. 1967) is rather excessive: ' this is frankly a mediocre work, in which two mannequins, dressed in elegant and fashionable clothes, are placed against a theatrical backdrop. An especially irritating feature is the dog, included probably at the wish of the sitters, and looking just as artificial and out of place as they themselves.'

9　Woody Slope with Cattle and Felled Timber, c. 1750. Oil on canvas, 102×91.5 cm. Minneapolis, Institute of Arts.

10-11　John Plampin of Chadacre, c. 1750. Oil on canvas, 49×59 cm. London, National Gallery.

12-14　Robert Andrews and Mary, His Wife, c. 1750. Oil on canvas, 70×118 cm. London, National Gallery. This is one of the best known of Gainsborough's works, and certainly the most famous of the paintings of his early period (*cf. pls 6-7*).

The Painter's Daughters, detail (see p. 26)

15-17 View of Cornard Village, 1750-5. Oil on canvas, 70×153.5 cm. Edinburgh, National Gallery of Scotland. Wealthy English art collectors of the time were not usually interested in collecting landscapes; if they did buy them, it was as articles of furniture. Landscapes, therefore, became used (as Gainsborough knew from direct experience in 1755) as ' mantel-pieces '. The painting *Woodcutter Courting a Milkmaid* (*pl. 22*), dated 24 May 1755 and sold by the artist to the Duke of Bedford for twenty-one guineas, was referred to as ' landscape for a mantelpiece '. But it was Gainsborough's particular merit to confer a new artistic dignity to landscape art. Until about the time of the Bath period, Gainsborough's landscape art was much influenced by the Dutch tradition, a tradition of direct contact with nature and objects, allowing no place for fantasy or the rhetorical and heroic grand manner of the Italian and French schools. It was a means of attaining a vision of the world which remained outside any unified, systematic conception of nature, and opted for chronicle in the place of history; it meant abandoning ideological and religious problems and all grandiose and tragic themes, to concentrate on the small problems of daily life: this emphasis led to a form of art which finally banished inspiration. While Hogarth was profoundly influenced by all aspects of this art, and absorbed much of its subject-matter, Gainsborough, on the other hand, merely took from Dutch painting certain landscape effects and the concept of painting as a bourgeois and anti-classical art.

18 Margaret and Mary Gainsborough, 1750-58. Oil on canvas, 75.5×62.5 cm. London, National Gallery.

Self-Portrait, 1754 (black and white illustration on page 19). Oil on canvas, 58.5×49.5 cm. Houghton, Marchioness of Cholmondeley collection.

19 Peasant with Two Horses: Hay Cart Behind, c. 1755. Oil on canvas, 108×128 cm. Woburn Abbey, Duke of Bedford. Initialled T. G. The Duke of Bedford bought this painting from the artist for the sum of fifteen guineas; the receipt is dated 24 July 1755.

20-1 River Scene with Figures, c. 1755. Oil on canvas, 94× 125.7 cm. St Louis, City Art Museum.

22-3 Woodcutter Courting a Milkmaid, 1755. Oil on canvas, 107×127 cm. Woburn Abbey, Duke of Bedford collection. Exhibited in Rome 1966. Keith Roberts writes: ' Compared to Gainsborough's Forest [*pl. 4*], this is a far more artificial type of landscape and it represents Gainsborough's attempt to master the rococo idiom of French contemporaries, such as Boucher. '

The Painter's Daughters, 1755-8 (detail, black and white illustration on p. 25). Oil on canvas, 113×150 cm. London, National Gallery.

Captain Thomas Matthew *(see p. 33)*

24-6 Sunset: Carthorses Drinking at a Stream, 1760-65. Oil on canvas, 142.5×152 cm. London, Tate Gallery. Gainsborough's Bath period fell between the years 1759-74; the works he painted during these years mark the summit of his creative achievement at the time when he modelled himself on van Dyck and Rubens. The type of painting he most frequently produced was the portrait, which was life-size and always against a background of nature; but at the same time several important landscapes were produced, which could

be described as genre works, such as this one, painted some time between 1760-65, and the later *Going to Market*, 1769 (*pls 30-1*), commissioned by Viscount Bateman. In these Bath landscapes, we are immediately struck by Gainsborough's extraordinary anticipation of the theories of the Picturesque, which were not formulated until many years later, in the famous essay on the Picturesque written by Sir Uvedale Price in 1794.

Mary, Countess Howe, c. 1765 (black and white illustration on page 21). Oil on canvas, 244 × 150 cm. London, Kenwood House, Iveagh Bequest. Roberts comments: ' Painted, together with a companion portrait of the lady's husband [*pl. 27*], the celebrated Admiral Howe, in the early 1760s, soon after Gainsborough had settled in Bath. The larger scale, the greater fluency of handling and the glamorous aura are symptomatic of Gainsborough's efforts to evolve, for his patrons in Bath, a more sophisticated style than he had either adopted or required in East Anglia. '

27 Admiral Earl Howe, c. 1765. Oil on canvas, 244 × 150 cm. Amersham, Earl Howe collection. Exhibited in Rome in 1966. In the catalogue to the Rome exhibition, G. Carandente describes Earl Howe as a naval officer who distinguished himself in the Seven Years' War, in the defence of the American coasts from French attack (1778), in the battle of Ushant (1794), and was made Admiral of the Fleet in 1796.

It is in portraiture that Gainsborough's technique is seen at its most inspired. The artist was fully aware that only through his own very individual natural gifts could he achieve what he was aiming for – the likeness of the model, together with a participation in nature; a study of character, together with freedom of technique: in other words, a synthesis of van Dyck, Rubens and Watteau in a new eighteenth-century style of great refinement. This was why Gainsborough did not wish to employ any assistants. He considered the setting in which his sitters were placed not as a mere ' background ' which could be left to the care of a studio hand, but as an essential part of the painting. Although it was the custom of the time to employ such assistants – a custom, moreover, imbued with the authority of Reynolds – Gainsborough's indifference to the opinion of others stemmed from his reliance on his personal vocation as an instinctive, self-taught artist. The society of Bath, from about the year 1760, consisted of a network of inter-related families from Bristol and Somerset. It was due to these high-placed acquaintances that Gainsborough was enabled to see the West Country collections and study the works of van Dyck and other classical artists for the first time. As Waterhouse wrote, ' Gainsborough's chief aim in portraiture during the next few years was to try to graft all the elegance he could learn from van Dyck (and we know that he visited Wilton amongst other houses) on to his own native, informal style. '

Many of the portraits were executed in London, where Gainsborough went every year on behalf of his most important clients. In a letter

Elizabeth and Mary Linley (see p. 33)

to Unwin dated 10 July 1770, referring to the Ligonier portraits (*pls 33, 34*), Gainsborough wrote that the two full-length figures were likely to keep him prisoner for a month's work. The particular study of light effects, filtered from the background and reflected in the silks and satins worn by his sitters, necessitated sympathetic lighting in the place where his painting was to hang. One of the main causes for Gainsborough's repeated arguments and quarrels with the directors of the Royal Academy was the method of hanging paintings adopted by that institution; he refused to submit his own paintings to this method and preferred to exhibit in his own home, where he could adjust the effects of light and distance from the floor at will.

28 John, 4th Duke of Argyll, c. 1767. Oil on canvas, 231.5× 153.7 cm. Edinburgh, Scottish National Portrait Gallery. Engraved in mezzotint by James Watson in 1769.

29 John, 10th Viscount Kilmorey, c. 1768. Oil on canvas, 233.5× 155 cm. London, Tate Gallery.

30-1 Going to Market, 1769-70. Oil on canvas, 119.5×146 cm. London, Kenwood House, Iveagh Bequest. Of this painting, Keith Roberts writes, ' According to an old tradition painted for the 2nd Viscount Bateman who was certainly a patron of the artist . . . A picture of a similar character, with the same title, belongs to the Royal Holloway College of Englefield Green.' (*Cf. pl. 24*).

Margaret Gainsborough, c. 1770 (black and white illustration on p. 23). Oil on canvas, 76×63 cm. London, National Gallery.

32 Gainsborough Dupont, c. 1770. Oil on canvas, 44×36.5 cm. London, National Gallery. This portrait is remarkable for the immediacy of its technique and its pictorial quality. Gainsborough Dupont was the nephew of the artist and the only person permitted to work with Gainsborough in his studio, despite the fact that it was the normal practice for portrait painters of the time to employ assistants to paint in the draperies, backgrounds and other accessories of the portrait. Dupont was taken into Gainsborough's family at the age of five and in 1772, when he was seventeen, he was officially taken on as his uncle's apprentice. In this portrait only the face is more or less completed, the clothes and background being barely sketched in. This would seem to indicate that Gainsborough's usual procedure was to complete the face entirely before working on the remainder of the painting. However, Reynolds admired Gainsborough for just the opposite quality: ' his method . . . of forming all the parts of his picture together; the whole going on at the same time, in the same manner as nature creates her works.'
This is a very interesting interpretation and is probably most appropriate to the works of Gainsborough's London period.

Mrs Harriott Marsham (see p. 34)

33 Edward, 2nd Viscount Ligonier, 1770. Oil on canvas, 239×157.5 cm. San Marino (California), Huntington Gallery. This is the companion picture to pl. 34.

34 Penelope, Viscountess Ligonier, 1770. Oil on canvas, 240×157.5 cm. San Marino (California), Huntington Gallery. As we have seen, in spite of the reciprocal esteem between Gainsborough and Reynolds, their opposing views gave rise to bitter quarrels. In a continuous confrontation, the two artists sometimes drew near to each other, while at other times they were poles apart. Even when Gainsborough came closest to Reynolds' point of view, he still maintained some substantial differences: for example, he did not portray the figure in a statuesque pose or in the idealized attitude which was typical of Reynolds. For the most part, the figure is bathed in a rarefied atmosphere and the distribution of light and dark tones is typical of the method of Gainsborough; the structure of the image therefore becomes pictorial or, more precisely, colouristic. In this portrait of Viscountess Ligonier, Gainsborough is not only very close to Reynolds but also shows the influence of neo-classical art as it had been developing in England and elsewhere during the preceding few years. But we should not forget that Reynolds himself, though a staunch defender of classicism, was harshly attacked by the neo-classicists (Blake, Fuseli, etc.) who rejected the Baroque elements in classical art. In this portrait, Gainsborough adopted a classical form for the dress and the objects composing the background to the portrait, but although the dress is antique in form, it is an antique which has been modernized. This represents a procedure diametrically opposed to that of Reynolds, who tended to paint modern dress in an antique, or historical, manner.

35 Jonathan Buttall ('The Blue Boy'), c. 1770. Oil on canvas, 178×122 cm. San Marino (California), Huntington Gallery. This is an answer to Reynolds' portrait of Thomas Lister (*The Brown Boy*, 1764). The origin of this particular dispute between the two artists is to be sought in their differing treatments of the clothes worn by the sitters. Reynolds, as we have seen, believed that costume should be depicted in an antique manner, since the figures were to be arranged in a 'classical' style. The argument therefore rested on the choice of an 'invented', as opposed to a 'realistic' costume; and while Reynolds emphasized his sitter's historical role, Gainsborough's interest was in his contemporary character. The reason for the difference in colour tones between the two works (warm brown in the case of Reynolds, cold blue in Gainsborough) is to be sought also in these opposing attitudes: brown is the colour produced in old paintings by the oxidation of the varnish. Besides, Reynolds had studied art in Italy, and was particularly impressed by the art of Venice and Emilia (Titian, Tintoretto, Correggio, Parmigianino, etc.), a type of painting in which warm tones (yellows, reds, browns) predominate, in addition to the effect caused by oxidation. Reynolds was compelled to make extensive use of varnish and glazes, since

he fixed appointments for his models at weekly or even fortnightly intervals. Gainsborough, on the other hand, worked more rapidly and could therefore paint on top of the fresh paint without need for varnishes. His favourite colours were blues and greens, cold and ' contrasting' tones, while warm colours more easily ' blended'. The warm, golden tone found in Reynolds' works was the tone typical of ancient painting; as a reaction to this imitation of the antique, Gainsborough wished to point the contrast between ' museum painting' and ' contemporary art'. *The Brown Boy* of Reynolds and *The Blue Boy* of Gainsborough were both taken from the same model: a famous portrait by van Dyck, the acknowledged father of the whole English school of portraiture. It was their interpretations of this original model which marked the difference between the two artists. Reynolds situated van Dyck in the Italian Baroque school, whereas Gainsborough saw him as part of Flemish and French culture and the basis for Watteau's rebellion against the widespread cult of Italy. The contrast was therefore between colour and tonality: between French and Italian schools of painting. *The Blue Boy* is dressed in a malachite-blue costume which produces a luminous effect – in fact, it is even more luminous than the sky. It should not be forgotten, however, that in 1782 Gainsborough attempted to reconcile his theories with those of Reynolds, when he painted *Master Nicholls, ' The Pink Boy'* (ill. in black and white on page 35).

36 Margaret and Mary Gainsborough, c. 1770. Oil on canvas, 231×150 cm. Biggleswade, Whitbread collection. Exhibited in Rome in 1966. Gainsborough painted this portrait of his daughters shortly after 1770. To the left of the viewer is Margaret, born in 1748. She married an oboe player and was so unhappy in her marriage that her mental balance was disturbed. The other daughter, Mary, was born in 1752; she remained unmarried and devoted herself to the care of her sick sister. This is certainly one of Gainsborough's important paintings, even if it shows some signs of slickness. Although the landscape is painted with great mastery, the figures are rather stiff.

Elizabeth and Mary Linley, 1772. (black and white illustration on p. 29). Oil on canvas, 195×150 cm. Dulwich College. Probably included in the Royal Academy exhibition of 1772. In that year Elizabeth Linley, a famous singer who was much acclaimed in London society, married the playwright Sheridan.

Captain Thomas Matthew, 1772 (black and white illustration on p. 27). Oil on canvas, 75×63 cm. Boston, Museum of Fine Arts. According to John Baker's diary, this unfinished portrait was seen in the artist's studio in 1772.

37 Mary Gainsborough, 1777. Oil on canvas, 76×67 cm. London, National Gallery. This dated portrait is unfinished, as is its companion, *Margaret Gainsborough*, in the Hirsch collection.

38-9 The Watering Place, 1777. Oil on canvas, 150×183 cm. London, National Gallery.

40-1 The Hon. Mrs Thomas Graham, 1775-77. Oil on canvas, 235×153 cm. Edinburgh, National Gallery of Scotland. This is one of Gainsborough's best known paintings; it was begun in 1775 and completed in 1777, and exhibited in the Royal Academy in the same year. At about this time Gainsborough executed a half-length portrait of the same sitter, now in the National Gallery, Washington. After 1774, he came under the influence of de Loutherbourg, a painter of only minor importance, whose experiments with painting and light effects fascinated Gainsborough. It seems that de Loutherbourg first experimented with glazes and transparencies on the occasion of his famous *Eidophusikon* exhibition of 1773. In the paintings shown at this exhibition, the artist made use of the techniques he learned when he worked as a stage designer for Garrick at the Drury Lane Theatre, and was able to create effects of mystery and magic. Gainsborough certainly drew on this source of inspiration in 1775, when he painted some full-length figures ' all transparent and lighted behind ' for Bach and Abel's concert hall; and again in this icily refined and masterly portrait of Mrs Graham. William Jackson makes on enlightening observation in this connection in his *Character of Sir J. Reynolds*: ' Gainsborough once dealt in red shadows; and, as he was fond of referring everything to nature, or, where nature was not to be had, to something substituted for it, he contrived a lamp with the sides painted with vermilion, which illuminated the shadows of his figures, and made them like the splendid impositions of Rubens. '

It was from 1777 onwards that Gainsborough began to receive commissions from the royal household which at that stage did not much care for Reynolds' ideas. Referring to the works of this period, Waterhouse writes: ' In all these [portraits] there is a heightened romantic feeling, a deliberate search for " glamour ", which, in the *Mrs Graham*, once the first feeling of astonishment at its fabulous dexterity has worn off, seems to fall into excess. These portraits are in a style of remarkable formal elegance which almost overshadows the painter's concern for likeness . . . , Gainsborough's gifts of giving a likeness are unimpaired: but his portraits become increasingly essays in poetic moods. The last important full-lengths in which the figures are still solidly planted on the earth, and in which the rival tendencies towards personality and pattern are in perfect control, are the *George III* and *Queen Charlotte* shown at the Academy of 1781. The latter must rank as one of the most splendid of all royal portraits. '

42-3 Fox Dogs, c. 1777. Oil on canvas, 83×112 cm. London, National Gallery.

Mrs Harriott Marsham, 1777-80 (black and white illustration on p. 31). Oil on canvas, 76×63.5 cm. Birmingham, Barber Institute of Fine Art.

Master Nicholls, The Pink Boy (see p. 36)

44 At the Cottage Door, c. 1780. Oil on canvas, 147.5×119.5 cm. San Marino (California), Huntington Gallery. This is one of the best known landscapes of the London period. Compared with the Bath landscapes, there is a more arcadian atmosphere and the influence of Thomson's *The Seasons* is apparent.

45 George Drummond, c. 1780. Oil on canvas, 228.5×147.5 cm. Oxford, Ashmolean Museum.

46-7 Mounted Peasant Driving Cattle over Bridge, 1781. Oil on canvas, 122.5×163.5 cm. Oxfordshire, Michaelis collection. Exhibited in Rome in 1966. In the catalogue to the Rome exhibition, G. Carandente referred to this painting as the one traditionally exchanged by Gainsborough for a violin with Mr Bowles of North Aston. Referring to this work, Waterhouse writes: 'The *Cattle crossing a bridge* is perhaps the most rococo, the most ornamental, of all Gainsborough's landscape compositions: it is also the only important one painted as an oval composition, though the canvas is square-cornered. and it was not painted for any specific place, as the artist is reputed to have exchanged it for a violin. The subject content, with pastoral lovers, is the same as in his early pictures. The ruined gateway (surely an artificial ruin?) is a new element which appears in several pictures at this date and is perhaps a concession to contemporary taste. The slowly swinging curves of the composition, which ultimately derive from Rubens, and their inclusion in the oval suggests a possible influence from French prints, and this picture is perhaps closer to Fragonard in mood than any other of Gainsborough's. It marks, however, rather the end of his first mature style: it carries that about as far as it can go, and a soft evening light bathes the picture in a warm, romantic glow. It must have seemed almost too light and ethereal to go with the eclectic classicism of the prevailing Adam style. and one can see why Gainsborough looked around for something different.'

Master Nicholls (The Pink Boy), c. 1782 (black and white illustration on p. 35). Oil on canvas, 180×125 cm. Waddesdon Manor, Bucks. Exhibited at the Royal Academy in 1782. According to Roberts, 'Gainsborough's debt to van Dyck is particularly clear in this picture, in the costume and pose, and also in the shimmering. delicate brush work, which creates the same impression of refinement and elegance that van Dyck was aiming at in his English portraits.' (*Cf. pl. 35*).

48 Georgiana, Duchess of Devonshire, 1783. Oil on canvas, 234.5×145.5 cm. Washington, National Gallery. The Duchess of Devonshire was one of the most prominent figures in the English aristocracy. She was painted also by Sir Joshua Reynolds in the portrait now in Chatsworth House, Derbyshire. (*Cf. pl. 49*).

49-50 Mrs Sheridan, 1783. Oil on canvas, 216×149.5 cm. Washington, National Gallery (Mellon collection). This portrait, together with the portrait of the Duchess of Devonshire (*pl. 48*), both datable to about 1783, represent two salient points in the ' painting of faces ' which occupied the last years of Gainsborough's life. In the large series of portraits of the 1780s, Gainsborough succeeded in freeing himself from the limitations imposed by a faithful likeness to the model, and he treated portraiture in such a way that it became an excellent vehicle for his vivid and original imagination. This discovery came late in his life, and it is said that when he was on the point of death Gainsborough expressed his bitter regret at having to leave life just when he was ' beginning ' to achieve something good with his painting. His diminished interest in producing a likeness of the model and his consequent development of a rather generic typology was counterbalanced by a newly awakened interest in history, in the manner of Revnolds. with references drawn from the context of the European tradition of van Dyck and Watteau, re-created in a dramatic form and to some extent already pre-romantic. It should be added that Gainsborough's innovations included those of technique, and his art acquired a greater degree of immediacy and freedom than Reynolds had ever shown. This was the soil from which his famous ' fancy pictures ' certainly originated.

51-3 Walk in St James's Park (The Mall), 1783. Oil on canvas, 119.5×144.5 cm. New York, Frick collection. Exhibited in Schomberg House in 1784. This painting bears a certain resemblance in its subject-matter and composition to Fragonard's famous *Shady Path*, painted in 1773-6 and now in the Metropolitan Museum, New York.

54-61 Five of the ' Twelve Landscapes on Glass ', c. 1783. Oil on glass, 28×33.5 cm. London, Victoria and Albert Museum. This series of landscapes, painted about the year 1783 (together with Gainsborough's drawings for his famous magic lantern, in the same year), marks the technical and experimental results of the principles applied by de Loutherbourg in 1781 to the moving pictures of his *Eidophusikon*. Gainsborough intended this series of landscapes to be lit up artificially from behind. However, even without such artificial effects, they have a clear, luminous atmosphere which anticipates Constable. It should also be recalled that at this time Gainsborough was passing from a group of seascapes (1781) to a historical type of painting, in the sublime and heroic manner of such artists as Salvator Rosa and Gaspard Poussin) and to a typically English type of landscape art, although it was not uninfluenced by Dutch painting (in the summer of 1783 Gainsborough spent some time in the Lake District). This form of painting evolved fully in the art of Constable. and in his lectures on the history of landscape (London 1836), Constable did not fail to acknowledge Gainsborough's decisive contribution to this art. In landscape art as well as portraiture, especially in the more spontaneous landscapes of the London period, which showed a great contrast to the ornamental decora-

tiveness of the Ipswich works, Gainsborough made a noteworthy contribution to the art of the Picturesque.

62-3 Rocky Mountain Valley with Shepherd, Stream and Goats, c. 1783. Oil on canvas, 96.5×122 cm. Philadelphia, Pennsylvania Gallery.

64 Two Shepherd Boys with Dogs Fighting, c. 1783. Oil on canvas, 220×155 cm. London, Kenwood House, Iveagh Bequest. It is known that this paintings was included in the 1782 exhibition at the Royal Academy. Keith Roberts comments: ' One of the most important of the so-called " Fancy Pictures " which Gainsborough began to paint in the 1780s ... it has an intensity of effect, more reminiscent of the novels of Thomas Hardy than of the eighteenth century pastoral convention. that Gainsborough seldom attempted and certainly never surpassed.' (*Cf. pls 74, 76, 77, 78*).

65-6 Mrs Sarah Siddons, 1783-5. Oil on canvas, 125×100 cm. This is one of the greatest masterpieces of this period. Thoré-Burger saw this painting in the Manchester exhibition of 1857, and wrote as follows (quoted by Waterhouse): ' The great tragic actress. who interpreted the passions with such energy and such feeling, and who felt them so strongly herself, is better portrayed in this simple half length, in her day dress, than in allegorical portraits as the Tragic Muse or in character parts. This portrait is so original, si individual, as a poetic expression of character, as a deliberate selection of pose, as bold colour and free handling, that it is like the work of no other painter. It is useless to search for parallels, for there are none. Veronese a little – but no. it is a quite personal creation. This is genius. '

67-9 The Baillie Family, 1784. Oil on canvas, 251×227 cm. London, Tate Gallery.

70 Mrs Hamilton Nisbet, c. 1785. Oil on canvas, 231×152.5 cm. Edinburgh, National Gallery of Scotland. Exhibited in Rome in 1966. Carandente writes: ' This great portrait was painted by Gainsborough in the last years of his activity. Mrs Hamilton Nisbet was born in 1756 and was probably aged about thirty at the time the artist painted her. '

71-2 William Hallett and His Wife (The Morning Walk), 1785. Oil on canvas, 236×178 cm. London. National Gallery. William and Elizabeth Hallett married in July 1785. According to Whitley, this painting, which was a wedding portrait, was completed in the autumn of that year. ' In many ways the finest of Gainsborough's late full length portraits, ' writes Keith Roberts.

73 Sophia Charlotte, Lady Sheffield, 1785-6. Oil on canvas, 225×148 cm. Waddesdon Manor, Bucks. Keith Roberts: ' The de-

mands of fashionable, society portraiture are judiciously combined with an evocative poetry entirely personal to the artist.'

74-6 The Market Cart, 1786-7. Oil on canvas, 182×153 cm. London, Tate Gallery. Painted in the year 1786 (and exhibited at Schomberg House in the same year) and 1787 (when the woodcutter with bundles of wood was added to the right of the composition). 'One of the artist's most ambitious landscapes,' writes Roberts, 'and the kind of Gainsborough that was to influence John Constable.'

77 Boy with Cat, 1787. Oil on canvas, 148.7×118 cm. New York, Metropolitan Museum.

78-9 The Wood Gatherers, 1787. Oil on canvas, 146×118 cm. New York, Metropolitan Museum. Towards the end of his life Gainsborough executed a series of works to which Reynolds gave the title 'fancy pictures', in order to underline the type of themes and backgrounds used in these paintings. There are affinities between these pictures and the works of Murillo, Watteau, Giorgione and Greuze. Some writers explain their origin as a result of the artist's withdrawal into himself and suggest that he returned to the themes of his early works, enlarged and isolated them in order to create imaginary compositions. Whether or not we accept this explanation, there can be no doubt that the content of many of these works anticipates the romantic movement and makes it possible for us to form a judgment on them as vehicles for the creation of forms, colours and pure rhythm. However, mythological and historical subjects were also not absent from Gainsborough's repertory, and in his last years he produced a small number of such works, the best known of which is the study for *Diana and Actaeon*, now in the Royal Collection in Buckingham Palace.

1

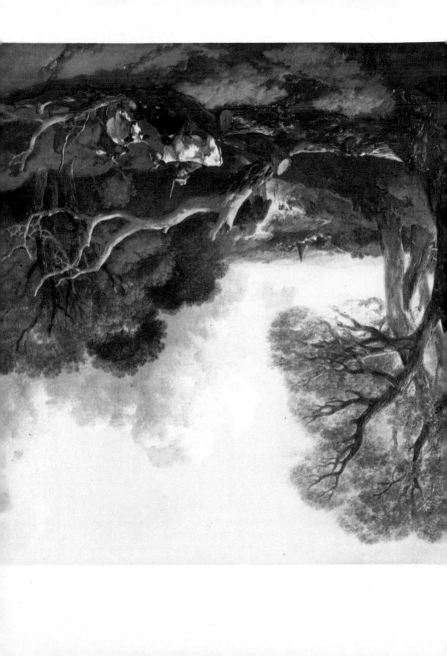

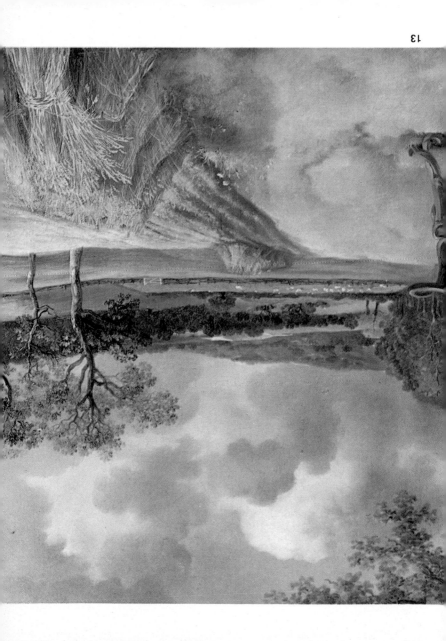

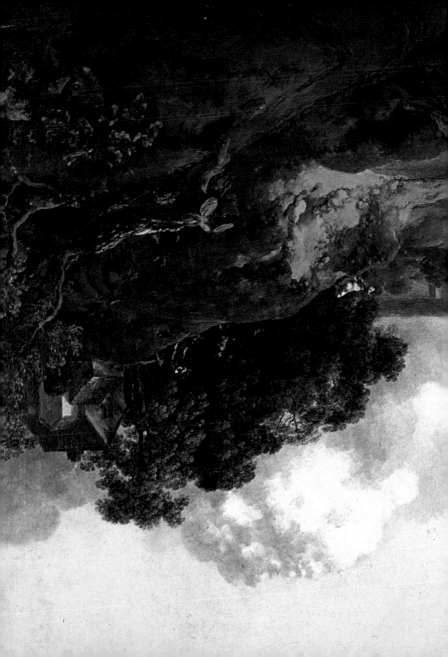

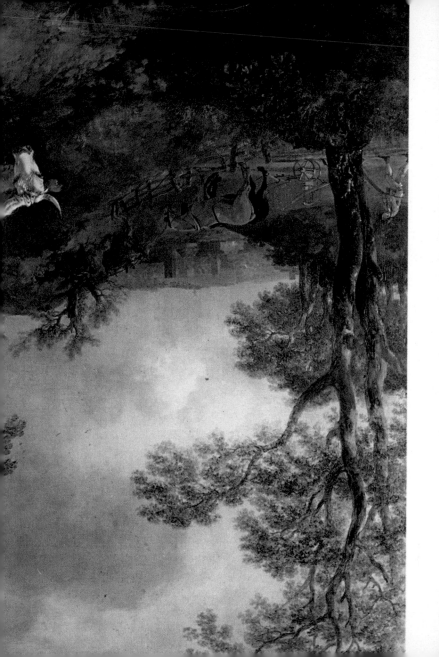

23

Jack The Killmeny.

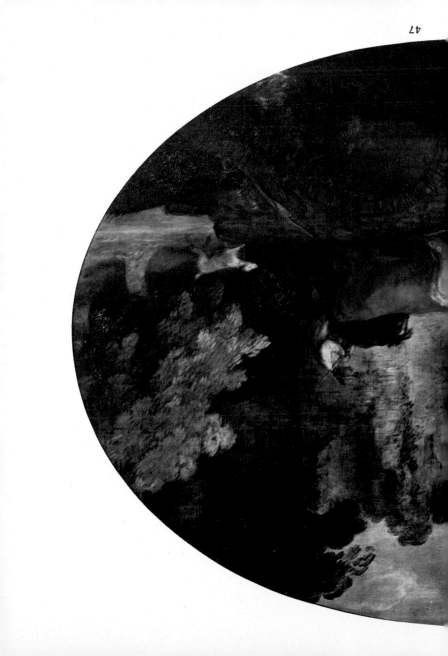

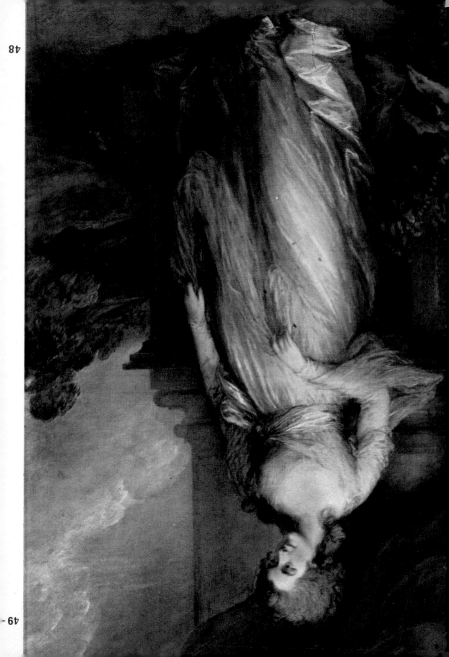

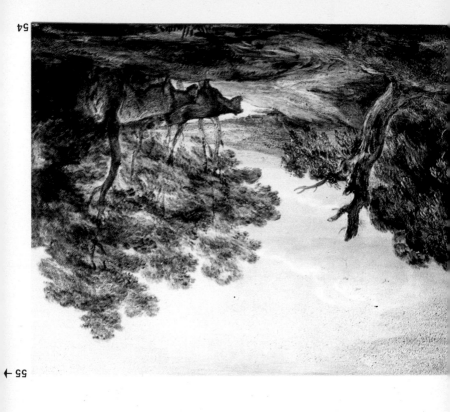

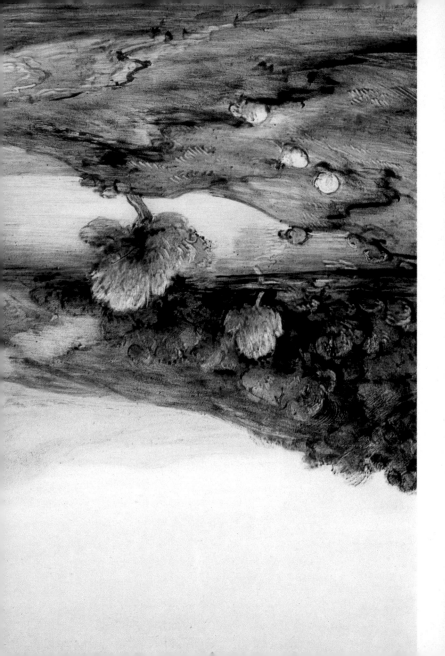

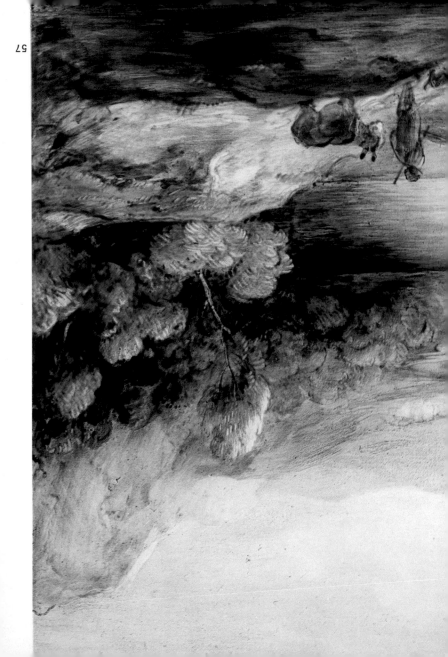

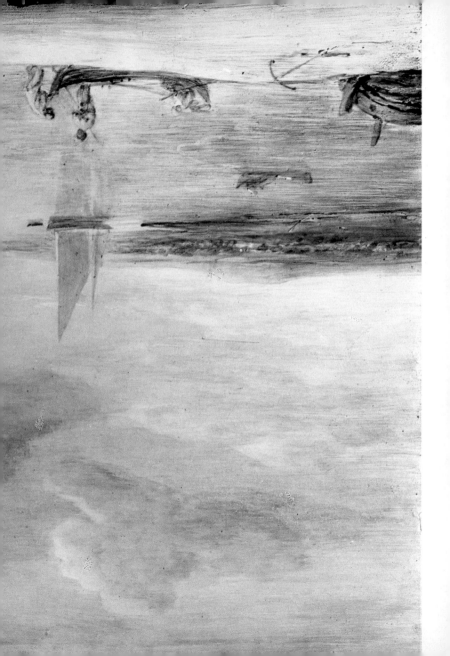

59

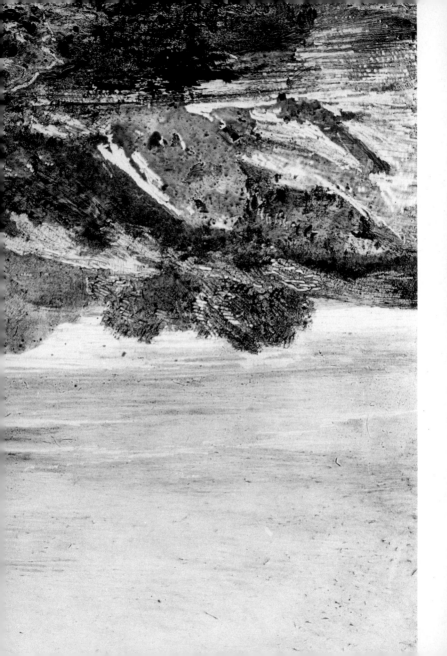